Persian Flora

AN ADULT COLORING BOOK

NAYERA MAJEDI

PERSIAN FLORA
AN ADULT COLORING BOOK

iUniverse books may be ordered through booksellers or by contacting:

iUniverse
1663 Liberty Drive
Bloomington, IN 47403
www.iuniverse.com
1-800-Authors (1-800-288-4677)

ISBN: 978-1-4917-9714-3 (sc)
ISBN: 978-1-4917-9713-6 (e)

Print information available on the last page.

iUniverse rev. date: 8/12/2016

INTRODUCTION

Sitting in a coffee shop one day, Nayera Majedi saw a design of a flower on the coffee cup and it flashed into her mind to sketch an outline to be filled with color as she had seen in a number of books of designs to color. Just after she had this idea, she started sketching a few stylized flower images in the Persian genre. This so gripped her attention that when she got home, she kept on sketching and sketching until in subsequent days, she had drafted over thirty initial images, that in later days, she continued refining according to her interpretation of classical Persian Painting style, each of these passing through four or five iterations before inking in the final designs.

Persian Flora is a collection of images of line drawings suitable for coloring with flowers and greenery that grows profusely in the verdant landscapes of our world. It is based on the spirals, swirls, curls, and curves of the natural world. These images are in constant flux with expanding and contracting depending on the seasons of the year. They are continually flowing, not uniformly but at their own pace, heavy in certain places and light in others. Everything is in play from narrower to stronger and the artist has followed the undulating pattern of nature from light to dark and back again with the attendant energy of each. It is fine art that is stable and strong with a balance of fullness and emptiness that can best be described by the emotion "I am in peace."

The artist has drawn these images according to classical and traditional scoping rules with alternation of curving lines that play with light and dark and expand and contract with energy creating dynamic landscape designs that balance flowers and fruits between filled and empty spaces. The outlines are strong and often reveal natural and composed images such as leaves with braided veins. Generalized foliage is arranged on stems in decorative patterns. Water pools and clouds are ripples of curls while the surrounding grass repeats varied leaf symbol types such as chrysanthemums, asters, and rosettes.

She has intended not to repeat any details throughout the designs and has made every effort to differentiate every image from all the others. She has reinforced this by labeling the names of the thirty-four distinct flower species such as Hyacinth, Anise, Cyclamen, Peony, Agave, Coreopsis, Juniper, Bird of Paradise, and Orchid Cacti. She has carefully researched these plants with an eye to extracting their essential features. She has used the principles of Persian Painting to capture and abstract their unique forms by which they are characterized. Especially noteworthy is a balance between intricate detail and large general curves. She has often softened the sharp edges of leaves so that they almost seem flesh-like. She has thought carefully of how best to draw each one, many of them exhibiting her signature clouds to represent liquid and fluff. Moreover, since plant nature is often seen from above looking down on them, all of the designs are equally attractive from the top or bottom of the page. Each flower image allows viewing without need of perspective entanglement. Besides her trademark signature of fluid cloudy shapes, she has incorporated a number of minute hearts as she observed how nature encrusts within clusters of stamens, stamens, pistols, and even leaves.

These outline drawings are highly conducive to being filled in with colorful shades, engendering the whole both by whetting the appetite of a person interested in coloring and allowing him or her to find pride in his or her choice of colors to complete a design. To further help the colorer, the artist would like to offer useful and knowledgeable hints and suggestions about these choices as they embark on the adventure of coloring these designs, especially in using pigments of red, purple, white and gold, and two greens, one dark and the other pale as may be found through reference to actual botanical photographs of the leaves and blossoms. In addition to curved lines engendering a spirit of energy and liveliness conducive to a viewer's active coloring and completing a design in color, they also encourage experiments in daubing and deepening strength of color from light to darker. Included are designer recommendations to maximize the effect of each final scene of portrayal of the natural beauty of flowers and vegetation, stems, leaves, petals, stamens, and ovaries to project the inner character of a design through coloration. To give the finished coloration a flush and glow of freshness, complementary values of coloring will progress to bright, intense, vivid, deep, fresh, rich, harmonious, and refined tints and hues.

Dr. Dian Terani

To my mom, who always loved flowers, who preferred my drawing
them instead of other subjects, and to whom I finally listened!

For their help in creating this book, I would like to thank Dr. David Fischer, Dr. Dian Terani, Dawn Dunsmore, Amene Vafai, Sarvin, Daniel for his idea of the cover design, and specially Soodeh who made every effort to translate the ideas into the final cover graphic.

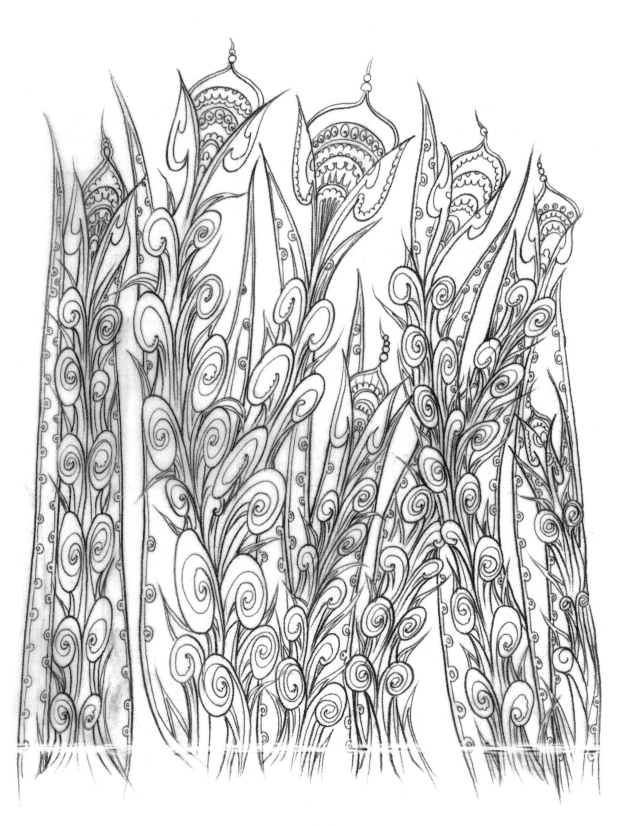

Aloe صبارا

Cyclamen Persicum نگونسار

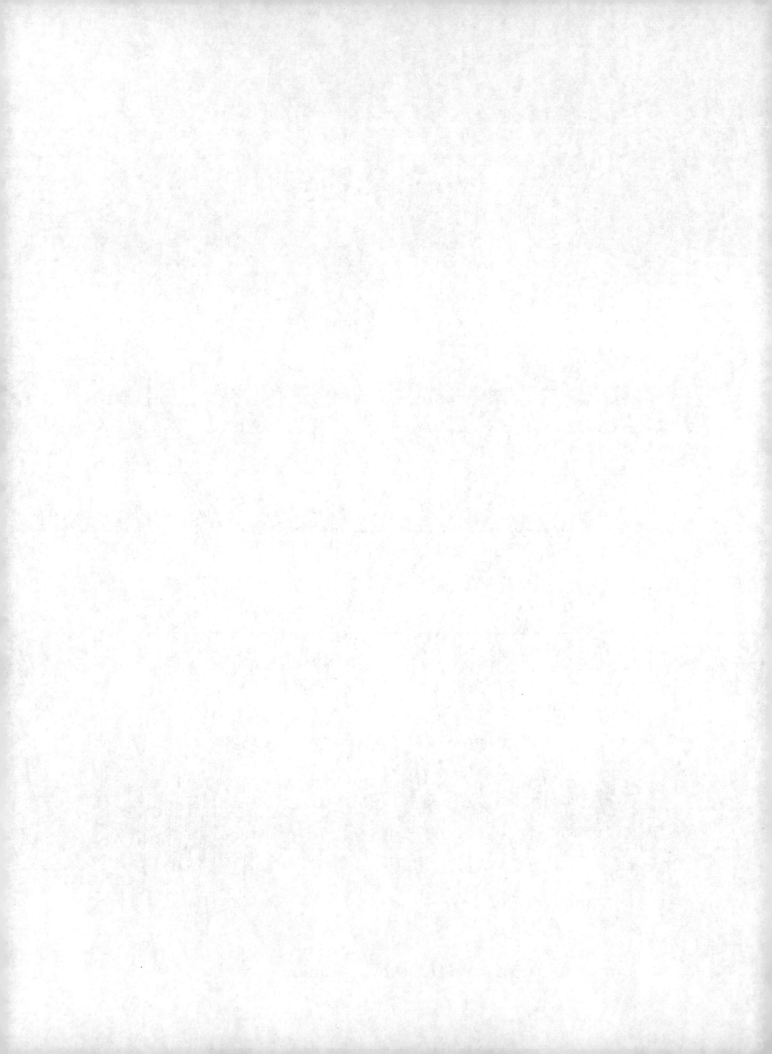

Nasturtium لادن

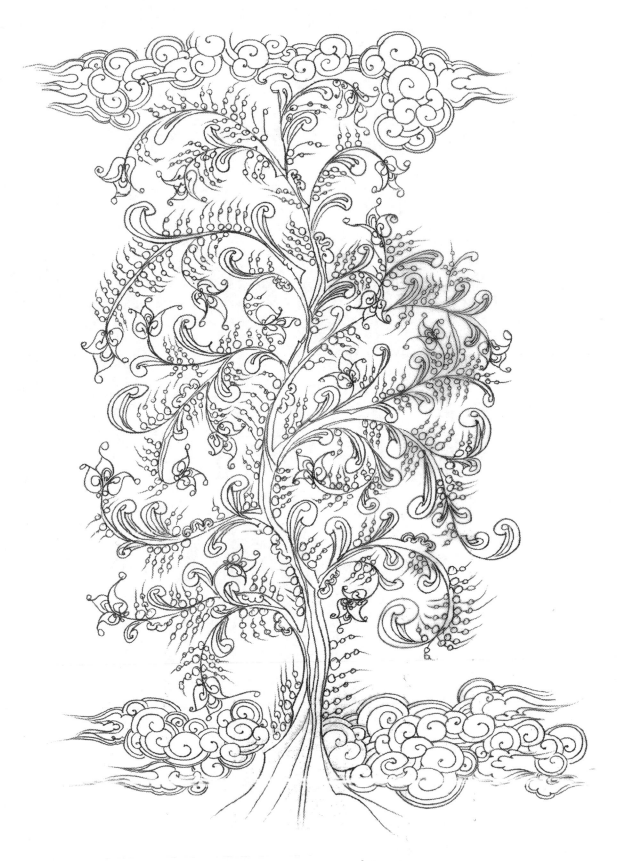

Bursting-Heart شمشاد

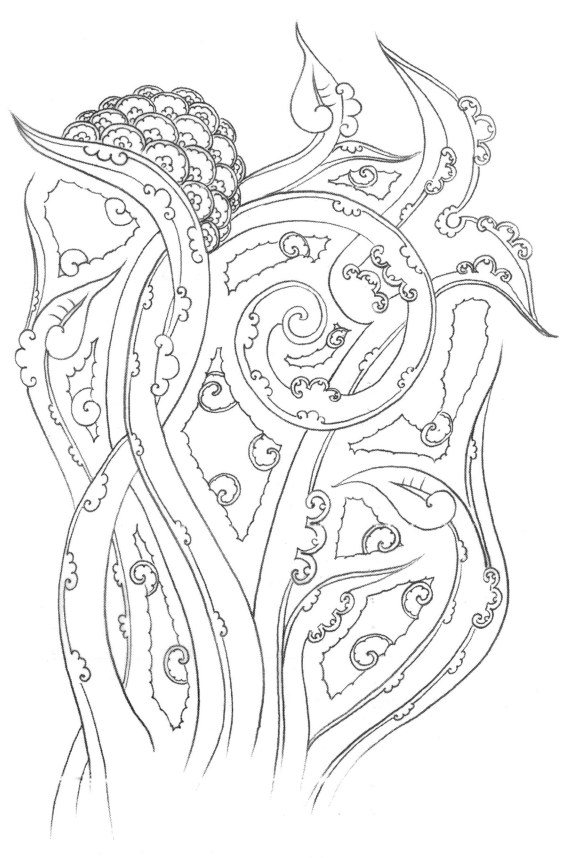

Hops كازر

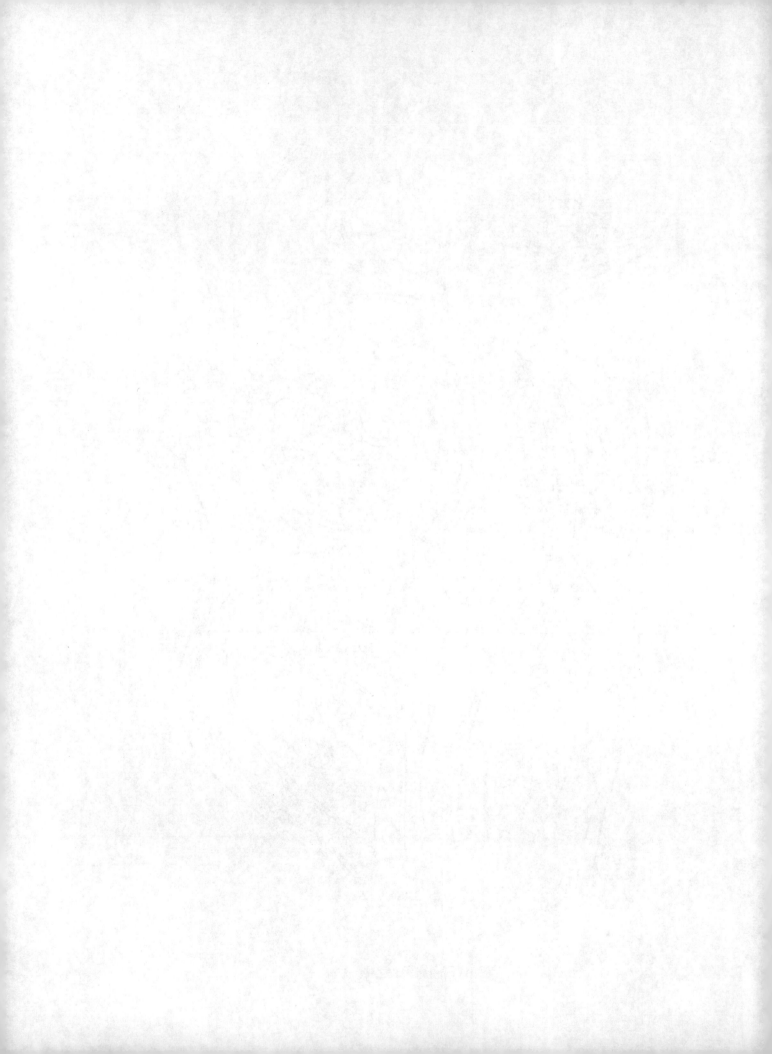

Callistemon/ Bottlebrush شیشه شور

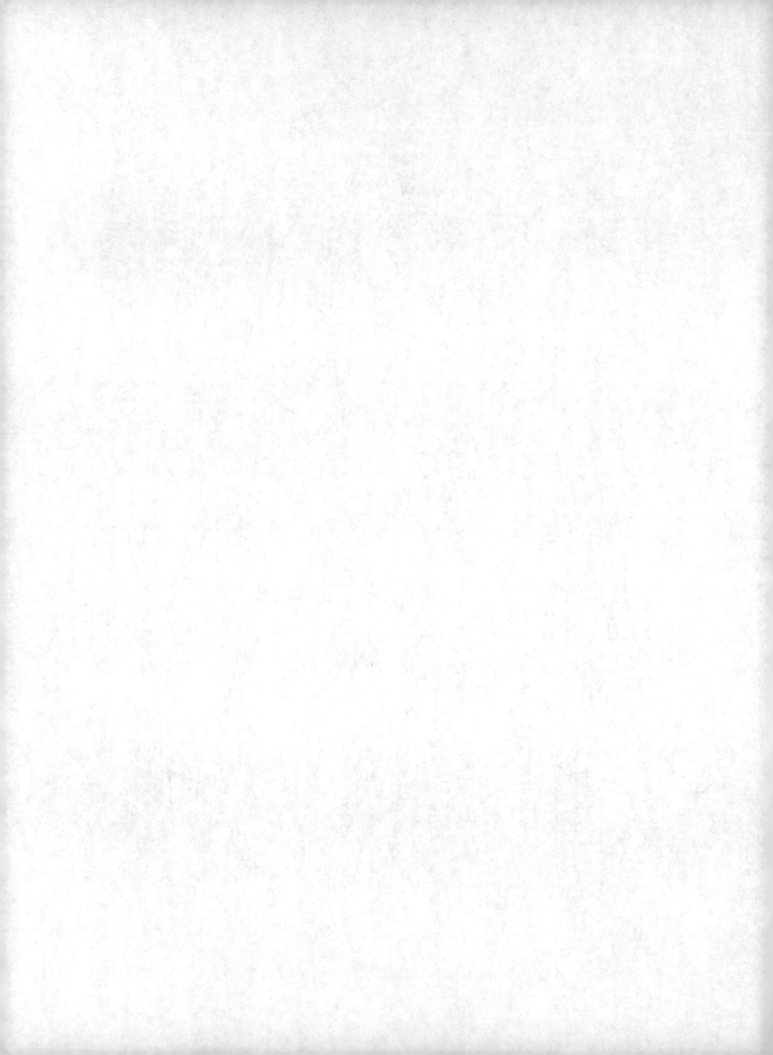

Bleeding-Heart دلخون

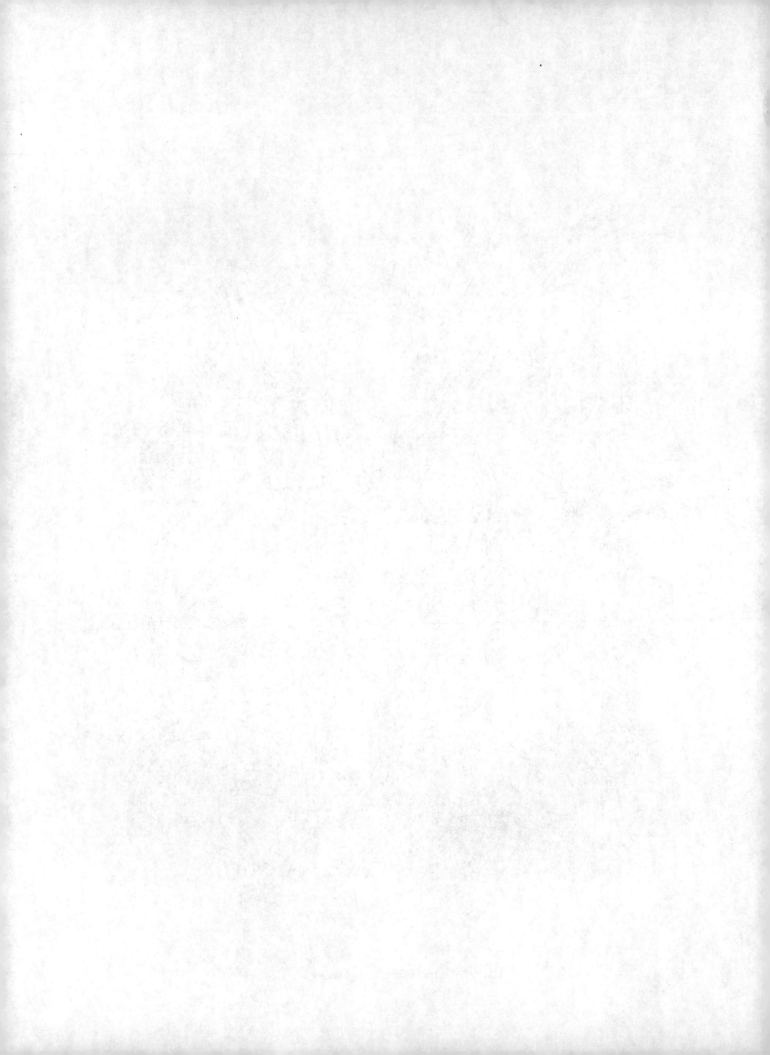

Bleeding-Heart دلخون

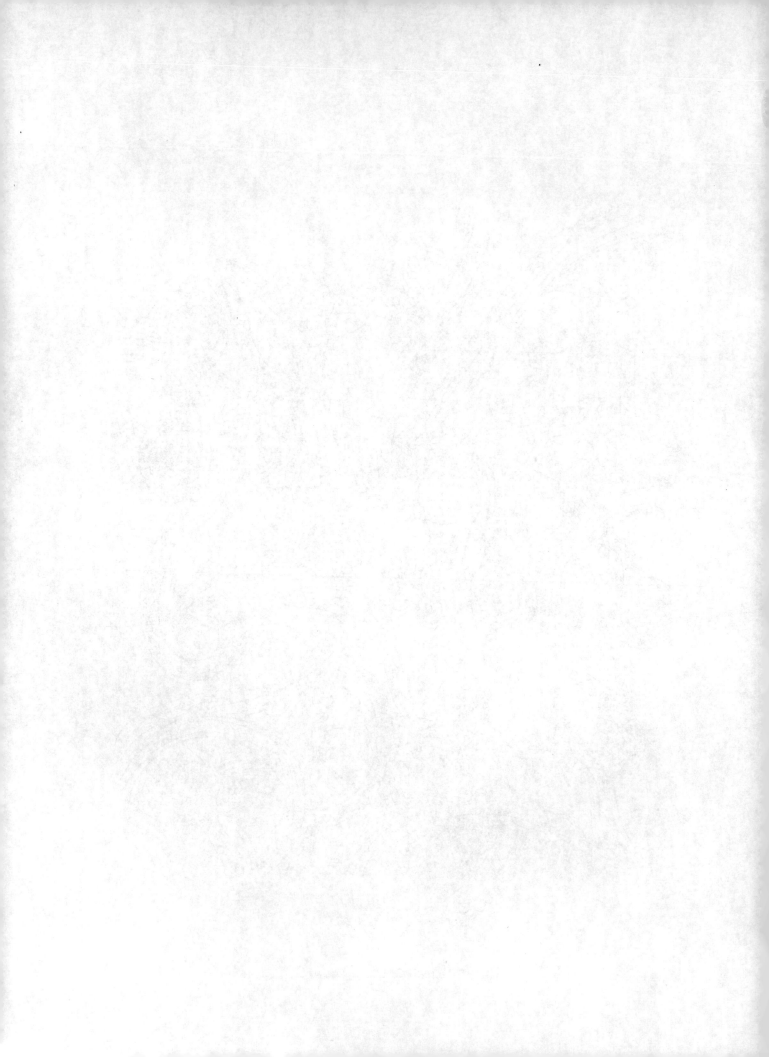

Abutilon ابوطيلون

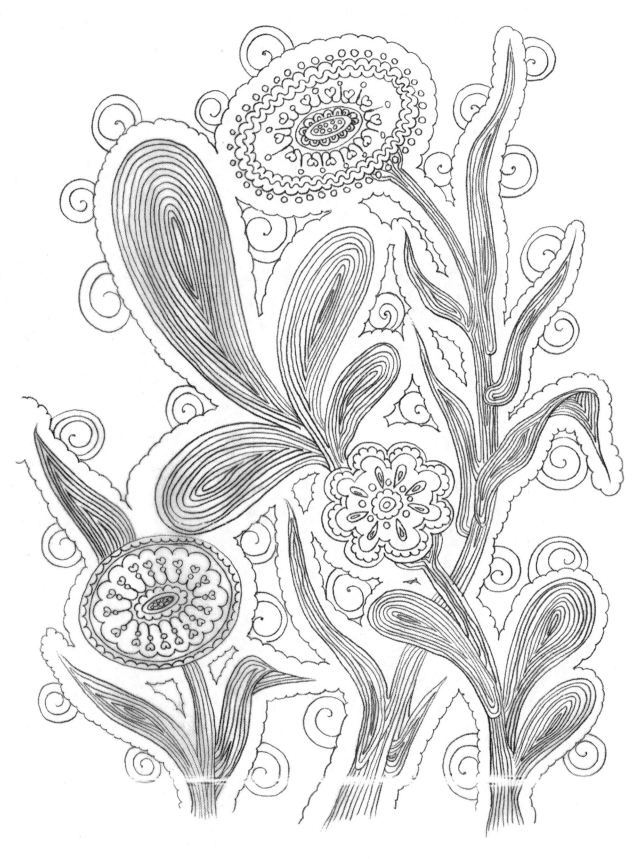

Anise انيس

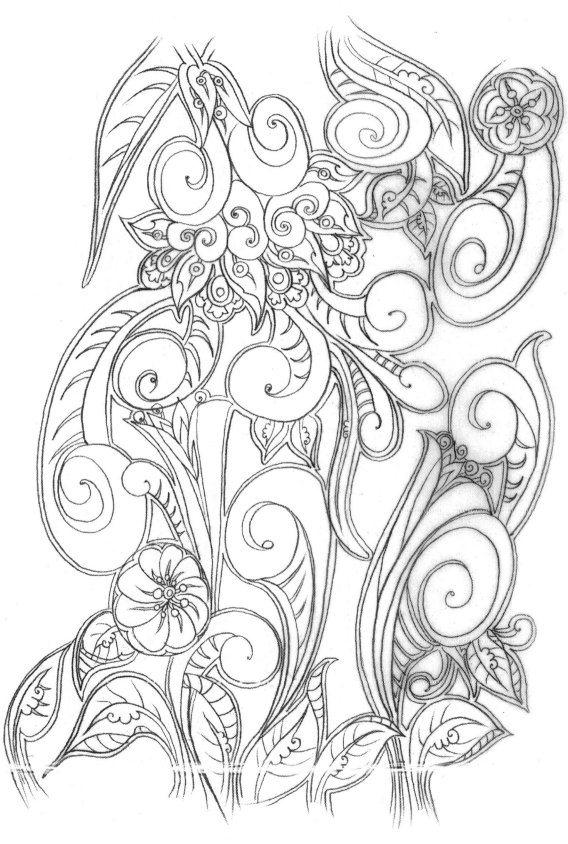

11- Honeysuckle پیچ امین الدوله

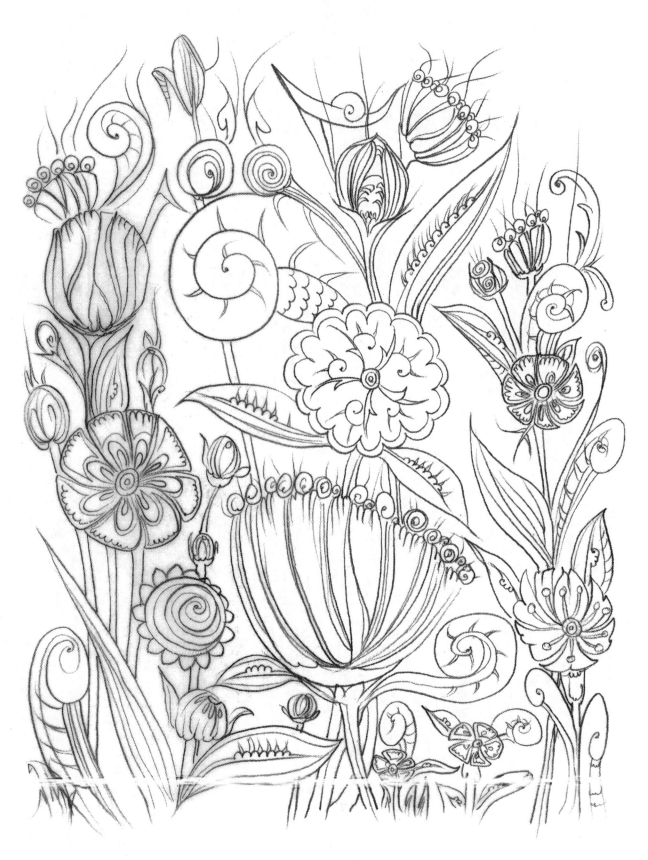

Gentian جنتيان

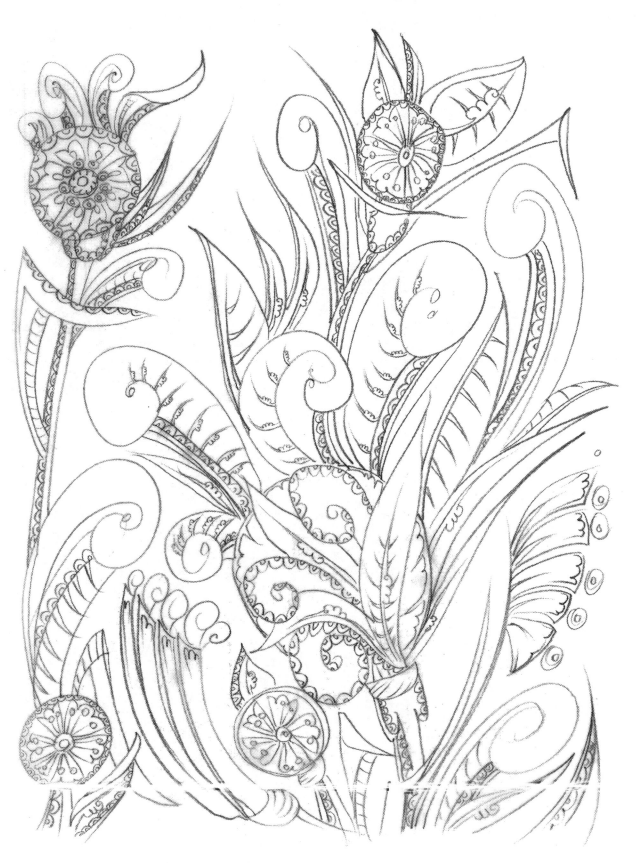

Lilium ledebourii سوسن چلچراغ

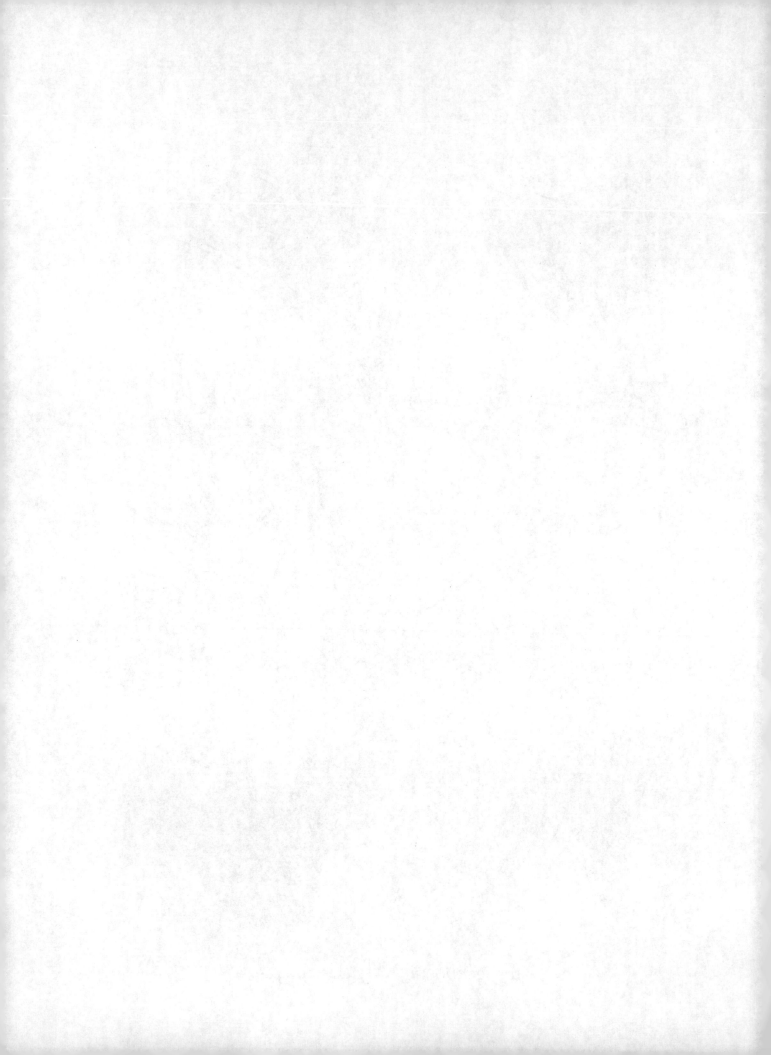

Lili of the valley موگه

Lantana شاه پسند

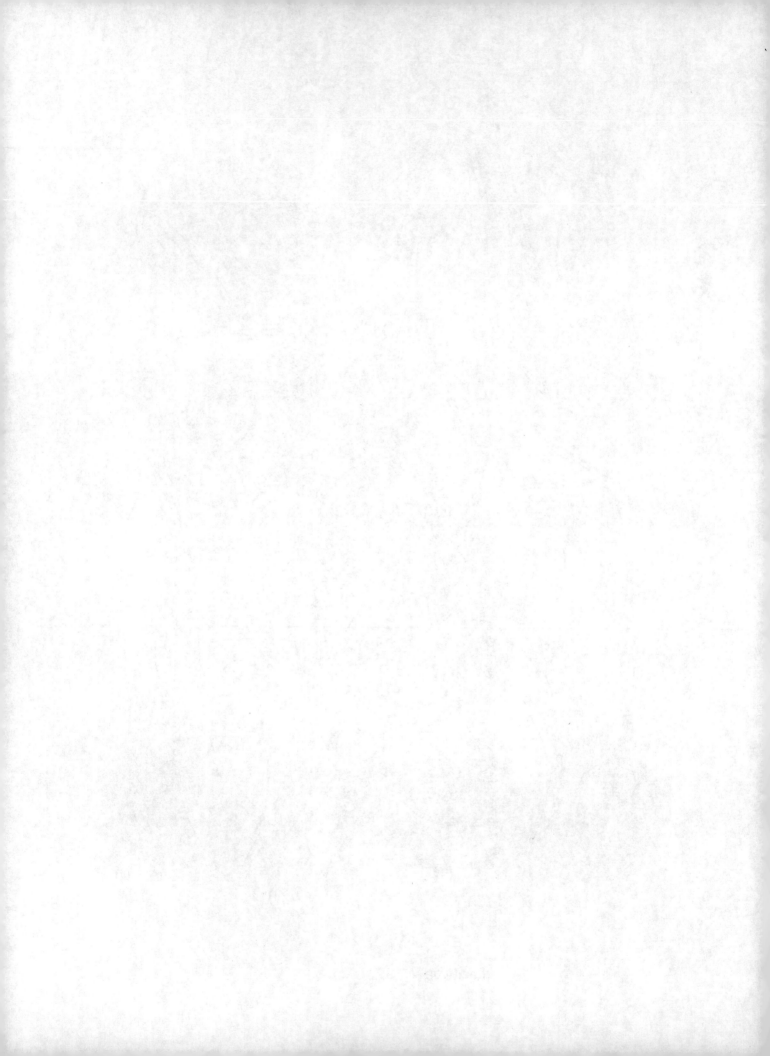

Milkweed استبرق

Peony صدتومني

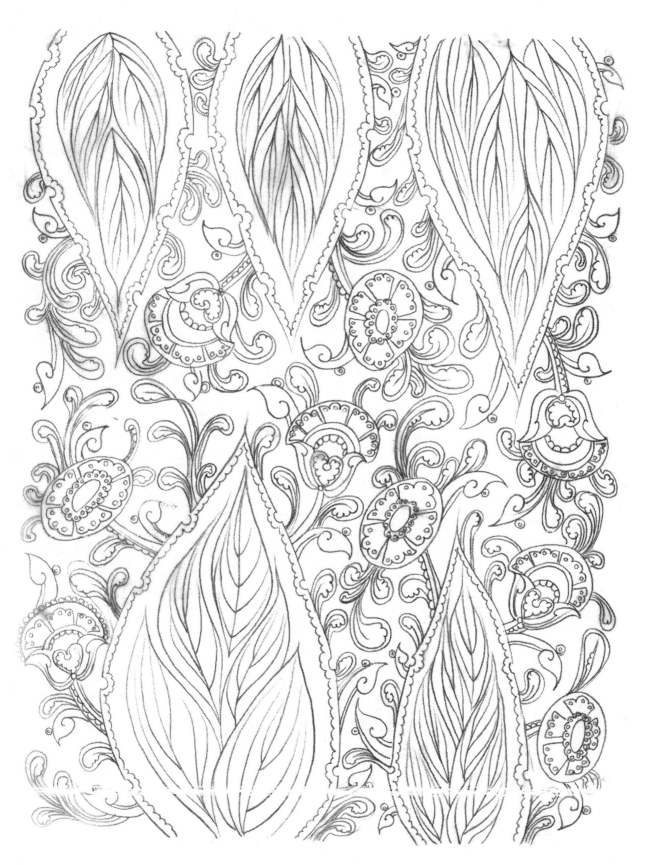

Cypress سروناز

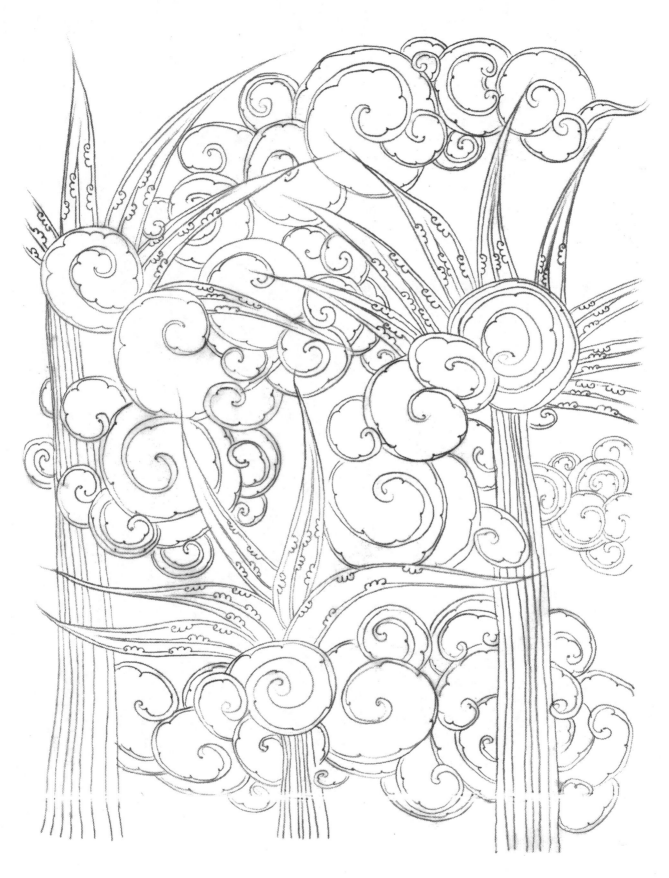

Agave خنجري

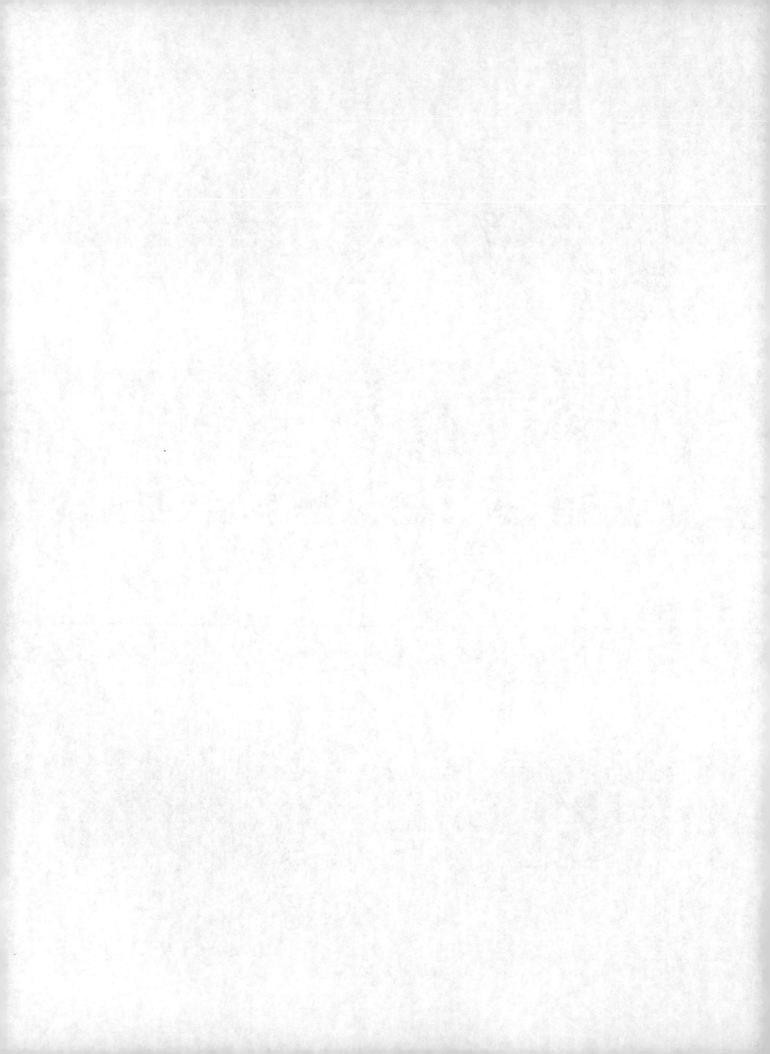

شقايق Puppy

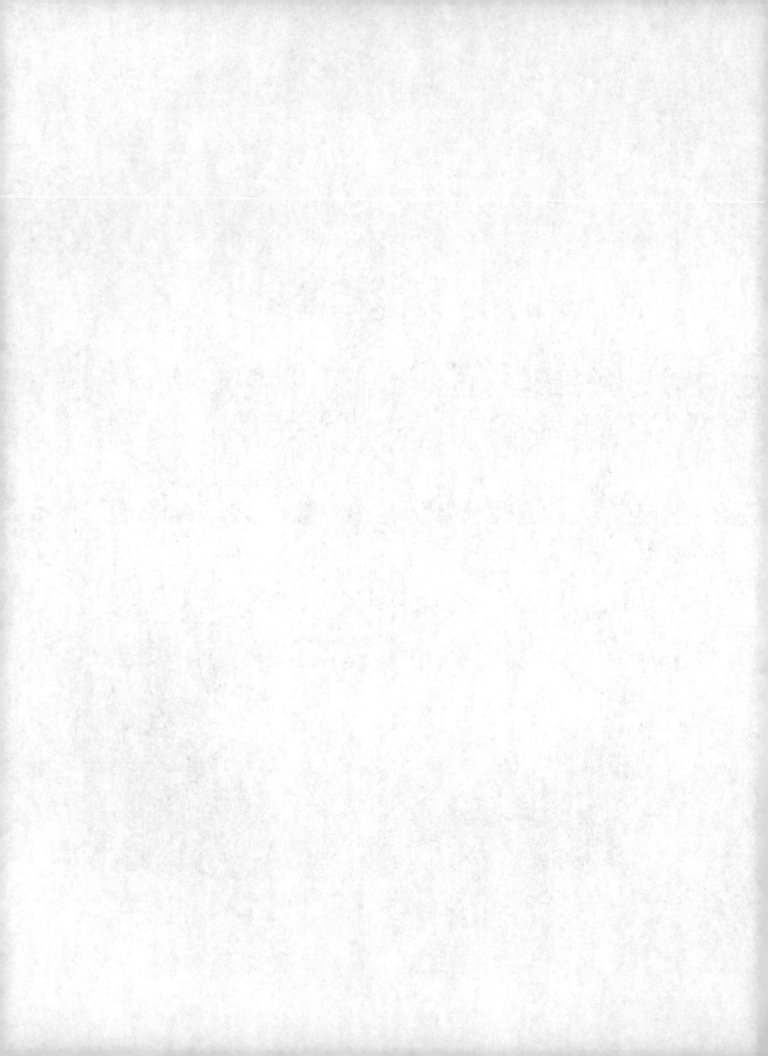

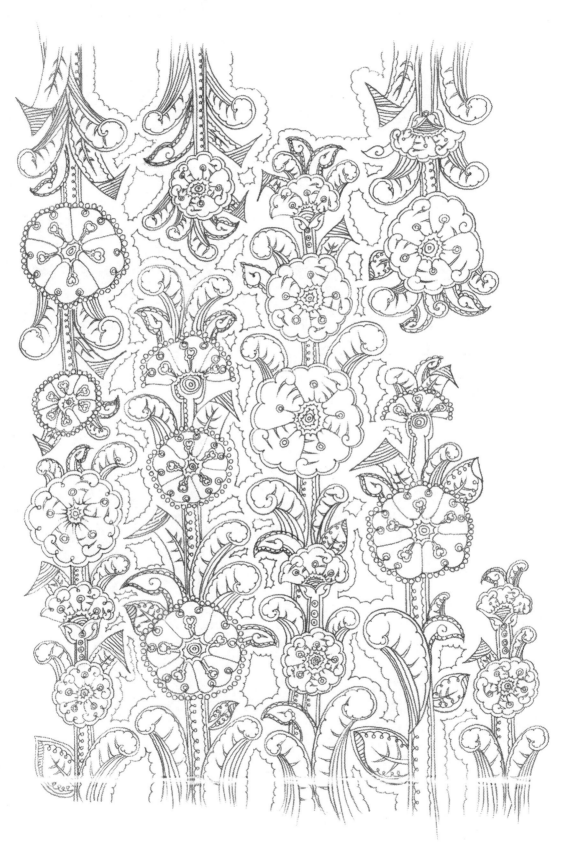

Primrose پامچال

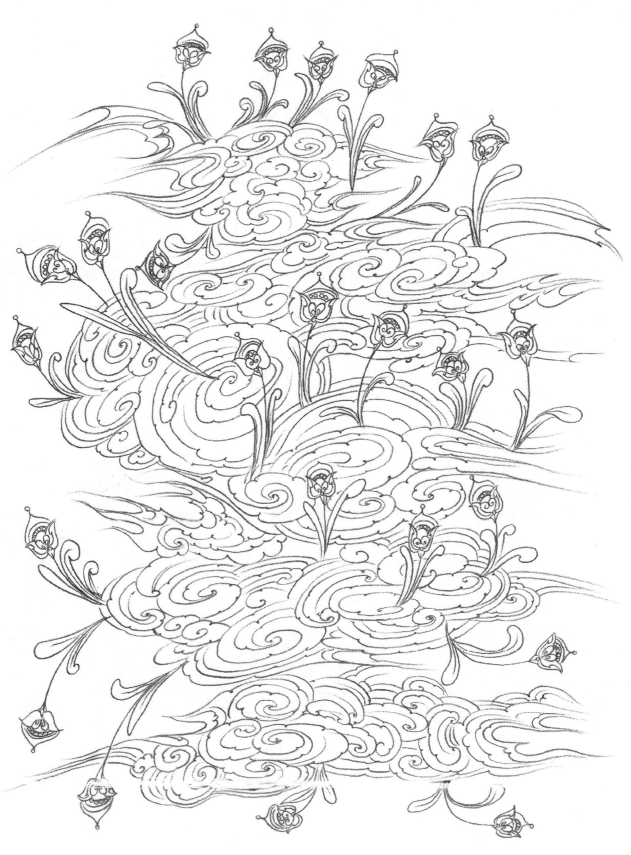

Garden sage مريم گلي

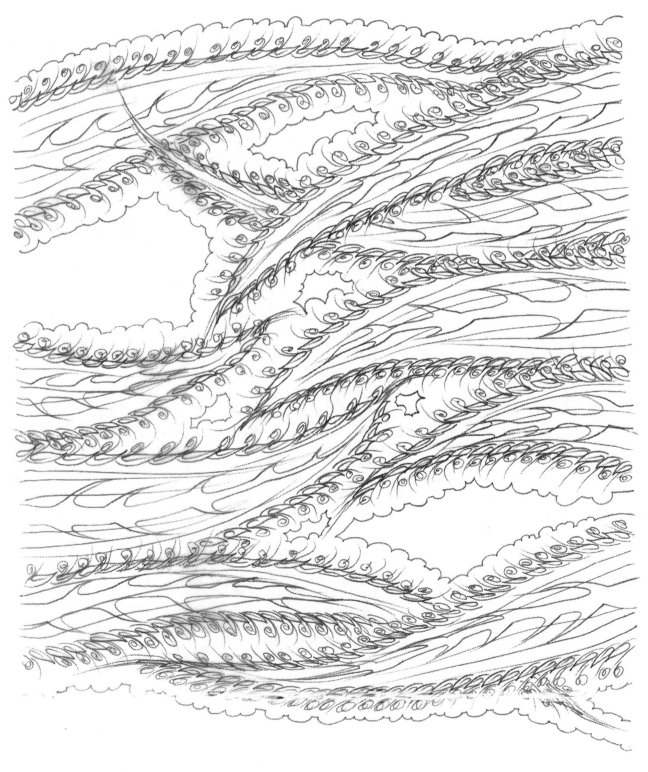

Melilot ناخنك

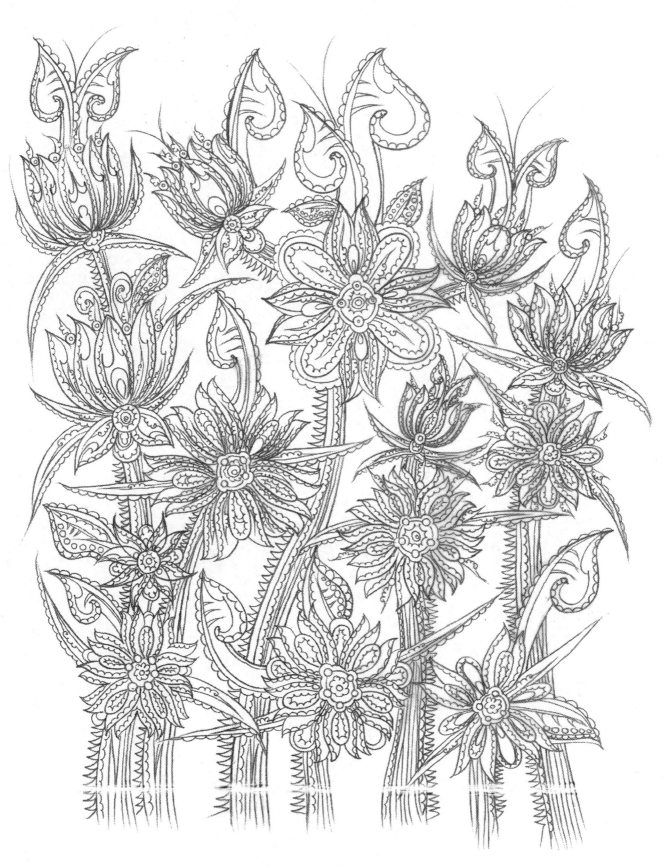

Bindii خارخاسك

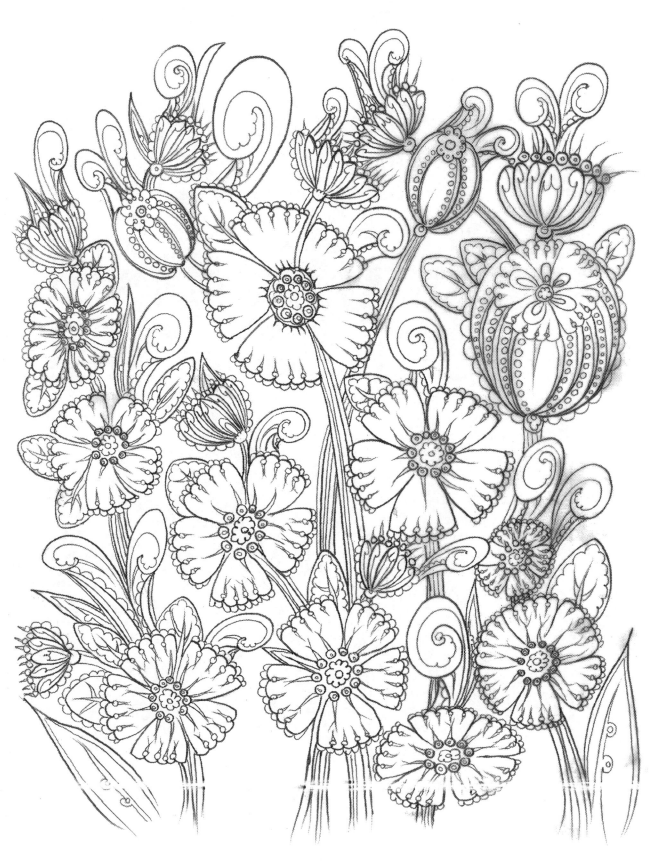

Centaury اشرفي

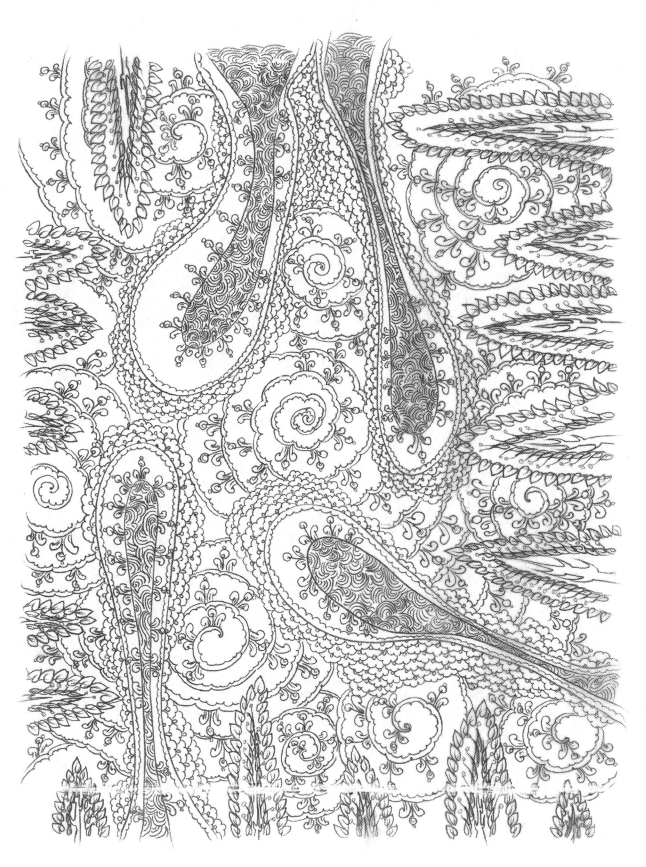

Live forever همیشه جوان

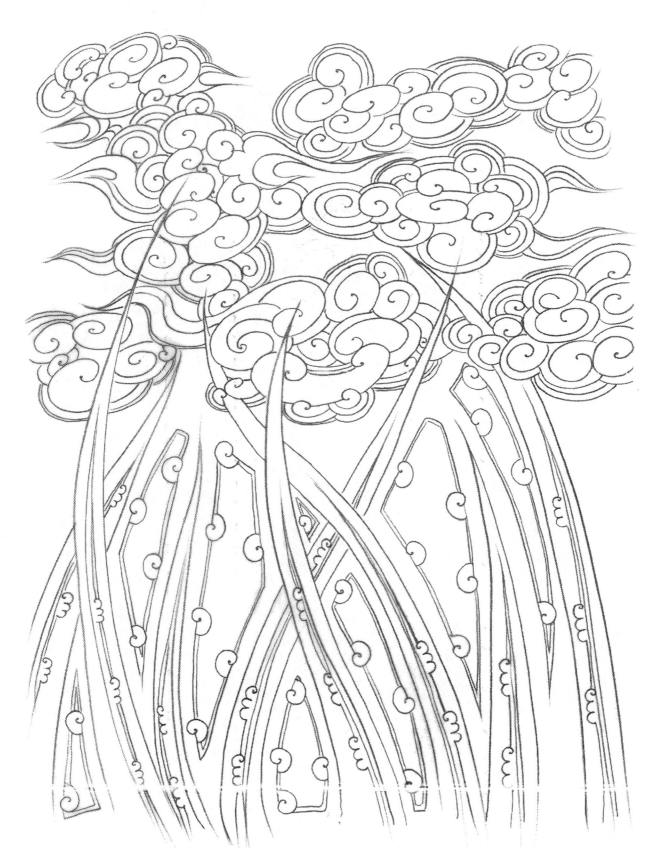

سرخدار Taxus

Savin سرو كوهي

Bird of paradise مرغ بهشتی

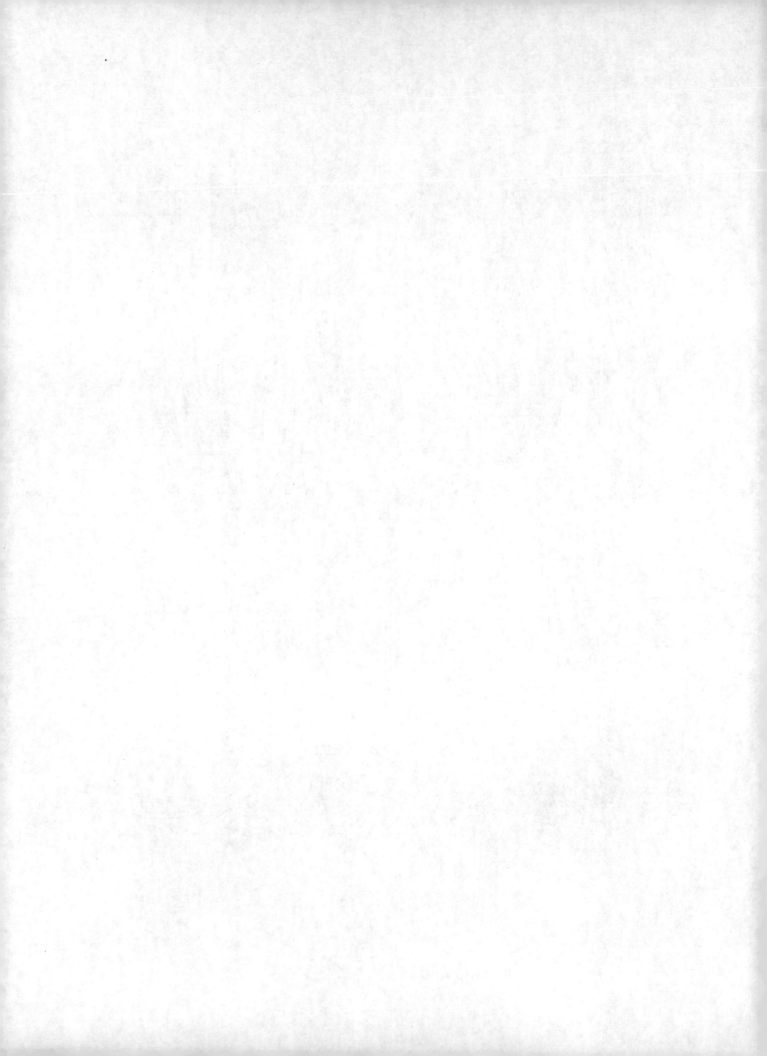

Mallow پنيرك

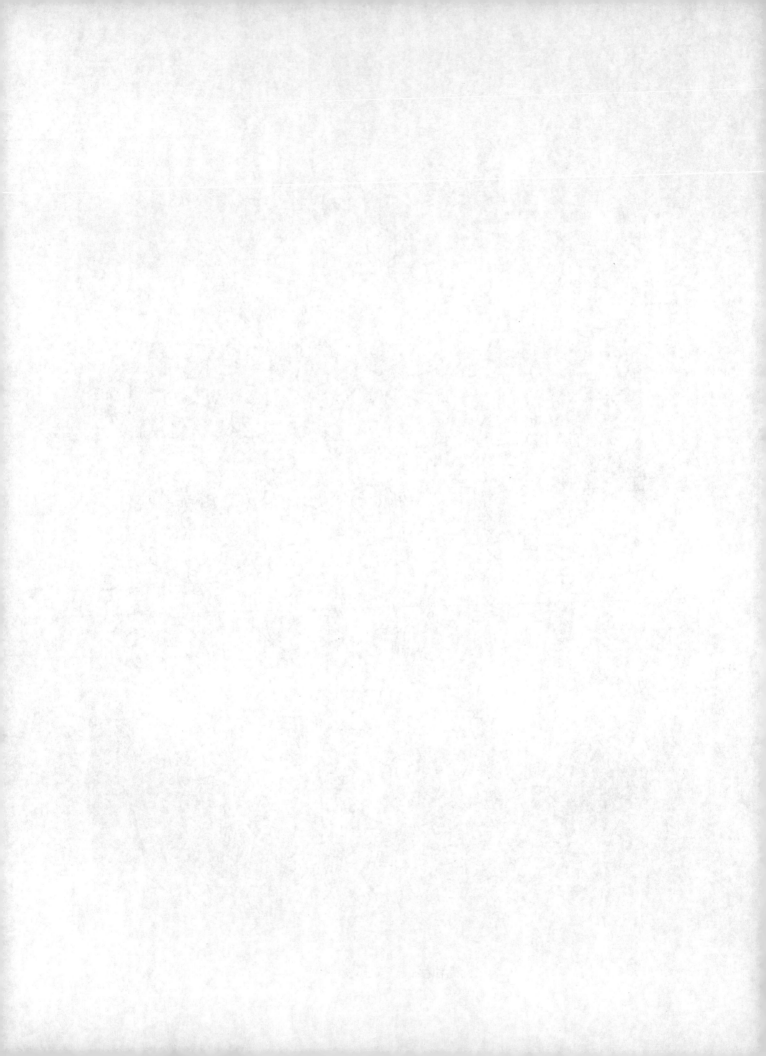

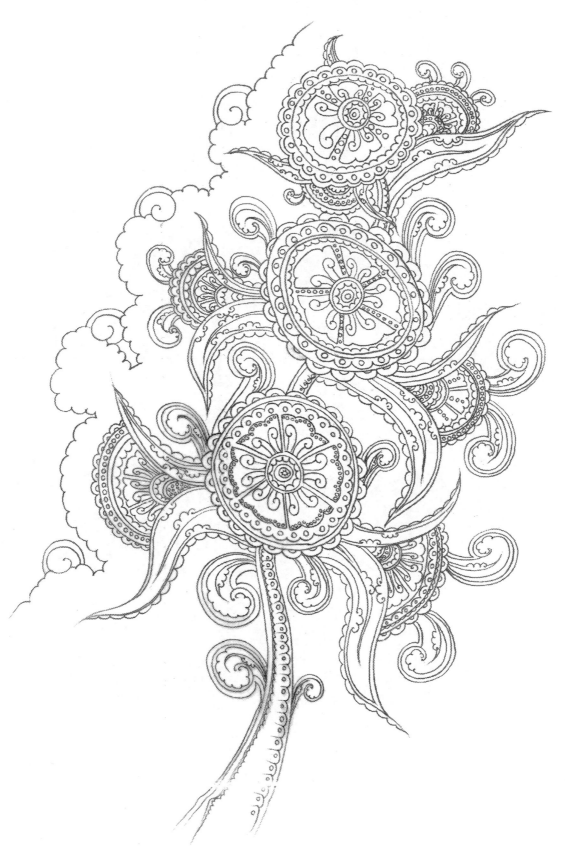

Thistles قاصدك

Snowdrop گل برف

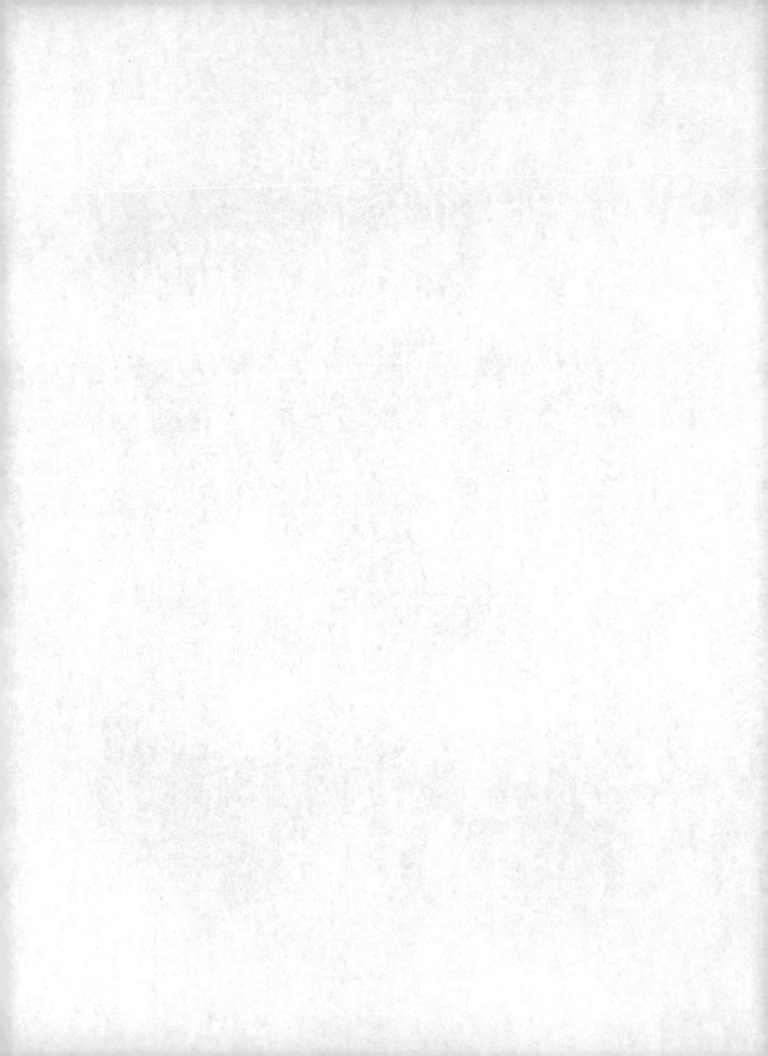

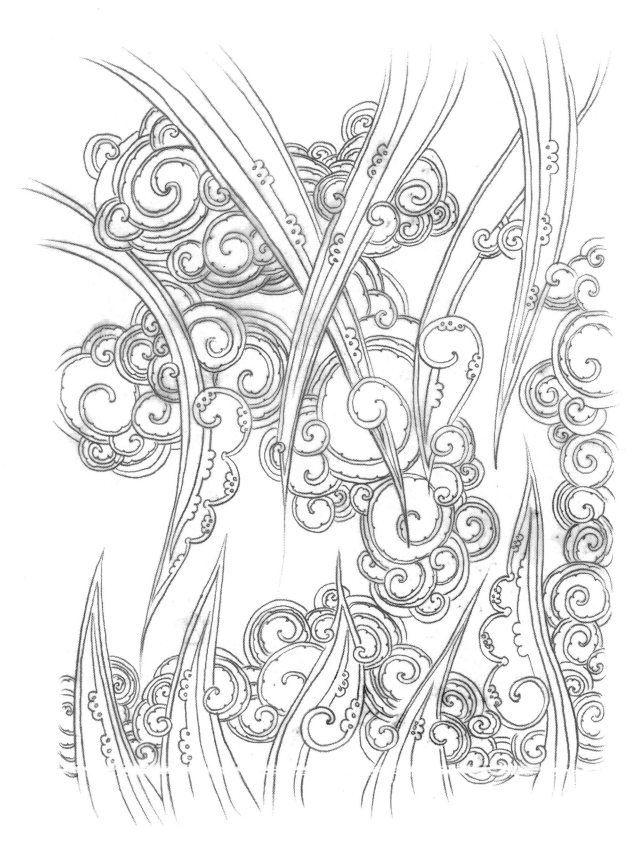

Ribbon Plant سنجاقي

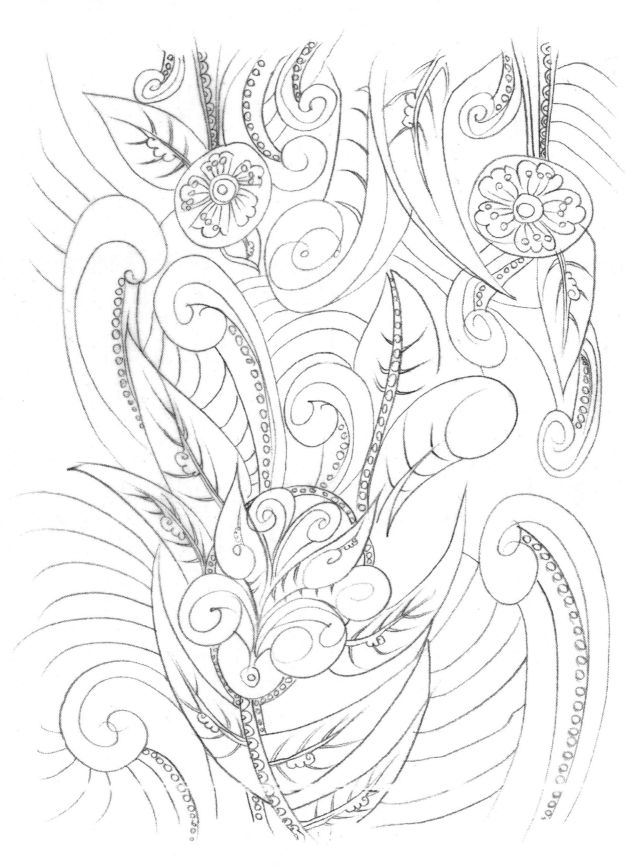

Obedience بادرنجویه

ABOUT THE AUTHOR

Trained as a classical miniaturist in the prestigious Tehran Visual Art Center, Nayera Majedi graduated in 1985. She was then an instructor for fifteen years, teaching courses that include Persian painting, gilding, drawing, and fundamentals of design and art at both the Tehran Visual Art Center and the Tehran Cultural Heritage Center for Traditional Art Studies (1986-1999). She has exhibited worldwide from Europe, the Middle East, to the United States. Her training allows her to be one of the foremost interpreters of the Classical tradition of Persian painting incorporating all the major periods of artistic development. While Persian paintings are generally constrained to small sheets of high quality paper, Nayera Majedi has extracted stylistic elements of floral design in these line renderings of classical images. In her own paintings, she adapts traditional colors, forms, patterns, and symbols into her own new style, especially distinguished by her signature clouds.